## Praise for
## *The Book of Wounded Sparrows*

"Octavio Quintanilla's *The Book of Wounded Sparrows* is simply a beautiful book, a lyrical journey within and through memory, language, identity, country, grief, family, and so much more. I'm particularly drawn to the gorgeous original artwork in the book—a combination of text and language, where mark-making begins to blend and interact with the mark-making of the poems. But mostly, I sense that this book is about absence and the ways in which the speaker tries to grapple with that absence, how to turn it, fill it, reshape it, draw it, but ultimately, the speaker knows silence can't be shaped, as Quintanilla writes: 'My relationship with language is absence, / one I can't shape with my hands.'"

—Victoria Chang

"Octavio Quintanilla unites, with striking clarity and effortless cohesion, stanzas in search of things unbroken, a desire for lost plenitudes—ancestry, whereabouts, language—the poet's personal archive of childhood letters, and his practice as an accomplished painter. In poems, paintings, and meditations on method, he animates each occasion with a distinct understanding of grid and coloration; with the volume and shadows that structure memory: 'What word to pack a wound? / What wound to fill a mouth?' This superb book fuses syllables and mark-making to match the two fires of affiliation, ever troubled by the complicity of one's own name, and the cause of that unsparing eviction. 'How many times have you dipped / your hand into the mirror / and tried to touch the last ripples / of what you are ceasing to be?'"

—Roberto Tejada

"*The Book of Wounded Sparrows* is an exquisite cartography of countries both real and imagined that cannot be bridged by a solitary body. 'Poetry remembers that distance can be made of suffering,' Quintanilla writes, and so the narrator shatters himself into a hundred pieces—grieving boy, lost man, wounded sparrow and wild dog all at once—and tells us, 'The sea forgives us / even if we don't want to be / forgiven.' Quintanilla understands that the work of the poet is to mourn, to remember, to pray, to dream, and beyond that, to collapse time and space and being, rendering ourselves whole, 'I want to ask my wife to hold me, / *hold me*, I want to say, / until all my flesh burns off // and all that's left is light.'"

—ire'ne lara silva

"In his long-awaited second collection of visual art and poetry, *The Book of Wounded Sparrows*, Octavio Quintanilla documents the tangled losses of migration by way of crossing the U.S.-Mexico border as a minor. Through finely cast poems whose lines cut and are cut as if with the thinnest of blades, Quintanilla tunes our witnessing to the loneliness and emotional costs of a child separated from his birth family, country, and tongue. To experience displacement at any age is to exist between languages, cultures, and familiars, and he captures this condition exquisitely: 'You don't know yet that a contraction is a visual form of separation: m    amá.' To be of both is to also never be whole: 'English is never enough. / Spanish is never enough.' Quintanilla's artwork splices the collection's poem sections, and I'm struck by the process of reading text and art separately and together, allowing the interplay of the resonant '[d]istance between blood cells.' This is a tenderly assembled book with hungers and thirsts I traced as if tracing my own."

—Diana Khoi Nguyen

"Former Poet Laureate of San Antonio (2018–2020), author of *If I Go Missing* (Slough, 2014), and creator of a colorful series of visual poems, Frontextos (a blend of frontera and texto—border/text), Quintanilla returns with his second book, about which the author says: 'It has taken approximately ten years to say, in less than 100 pages, what I've been wanting to say since I first started writing in English.'"

—Diego Báez in *Letras Latinas Blog*

# The Book of Wounded Sparrows

# The Book of Wounded Sparrows

## Poems

**OCTAVIO QUINTANILLA**

Con[text]ual

TRP: THE UNIVERSITY PRESS OF SHSU
HUNTSVILLE, TEXAS 77341

Copyright © 2024 Octavio Quintanilla
*All Rights Reserved*

Cataloging-in-Publication data is on file with the Library of Congress.

FIRST EDITION

Front cover art: Octavio Quintanilla,
"Boy With Wounded Sparrows,"
2024, mixed media on canvas.
Author photo courtesy of Octavio Quintanilla

Cover design by Cody Gates, Happenstance Type-O-Rama
Interior design by Maureen Forys, Happenstance Type-O-Rama

Printed and bound in the United States of America
First Edition Copyright: 2024

TRP: The University Press of SHSU
Huntsville, Texas 77341
texasreviewpress.org

# Con[text]ual

Illuminating the intersection of visual art and text in the context of ideas that deepen our understanding of the contemporary world.

*Books in this series:*

Jennifer Sperry Steinorth, *Her Read, a Graphic Poem*

Octavio Quintanilla, *The Book of Wounded Sparrows*

# Table of Contents

## I

Mamá y Papá . . . . . . . . . . . . . . . . . . 1

A Mother's Day Card . . . . . . . . . . . . . . 3

Vanishing Point. . . . . . . . . . . . . . . . . 5

Parting . . . . . . . . . . . . . . . . . . . . . 7

New God . . . . . . . . . . . . . . . . . . . . 8

Loneliness . . . . . . . . . . . . . . . . . . . 9

Leaving . . . . . . . . . . . . . . . . . . . . . 10

Postscript . . . . . . . . . . . . . . . . . . . . 11

Manifesto for Wanderers . . . . . . . . . . . . 15

The Children . . . . . . . . . . . . . . . . . . 16

Love of My Life . . . . . . . . . . . . . . . . . 17

Vulnerability . . . . . . . . . . . . . . . . . . 18

Four Fears . . . . . . . . . . . . . . . . . . . 19

There will always be a city . . . . . . . . . . . 20

Camaraderie . . . . . . . . . . . . . . . . . . 22

Mexican Pastoral . . . . . . . . . . . . . . . . 23

Strong Bond . . . . . . . . . . . . . . . . . . 24

Essay on Loss . . . . . . . . . . . . . . . . . . 25

Oración . . . . . . . . . . . . . . . . . . . . . 27

Hay días . . . . . . . . . . . . . . . . . . . . 28

Me siento solo . . . . . . . . . . . . . . . . . . 29

Lloro tu nombre . . . . . . . . . . . . . . . . . 30

Bosque de las palabras perdidas . . . . . . . . 31

Que bonito infierno . . . . . . . . . . . . . . . 32

¿Qué parte de tu memoria? . . . . . . . . . . . 33

# II

Self-Portrait with My Father's Eyes . . . . . . 35
Migrations . . . . . . . . . . . 36
Remember . . . . . . . . . . . 37
The Poetics of Separation: A Micro-Essay . . . . . 39
Country of Words, a Lipogram . . . . . . . 40
Why You Never Get in a Fight in Elementary School . . 41
Line & Metaphor (1) . . . . . . . . . 42
Ars Separation . . . . . . . . . . 43
Never Been to El Paso, TX . . . . . . . . 44
Psalm . . . . . . . . . . . . 46
A Sueldo . . . . . . . . . . . 48
Letter to the Afternoon . . . . . . . . 49
Letters . . . . . . . . . . . 50
New Country . . . . . . . . . . 51
Final Wishes. . . . . . . . . . . 52
Poem Writing A Suicide Note . . . . . . . 53
Desaparecer . . . . . . . . . . 56
Drawing the Line . . . . . . . . . 58
Elegy for Your Absence . . . . . . . . 59
La luna de los huérfanos . . . . . . . . 61
La tierra nos llamó. . . . . . . . . 62
Yo soy la ventana . . . . . . . . . 63
Nos encontramos en el camino . . . . . . . 64
¿A dónde va la luz?. . . . . . . . . 65
Las golondrinas no vendran . . . . . . . 66
Los botes llegaron vacíos . . . . . . . . 67

# III

Line & Metaphor (2) . . . . . . . . . 69
Despierta. . . . . . . . . . . 71
My Despair as the Voice of God . . . . . . . 72
Elemental Waiting . . . . . . . . . 73
[You take a picture of your father] . . . . . . 74
Fig of Unfolding . . . . . . . . . 75

Gregor Samsa's Sister . . . . . . . . . 76

Broken Names Like Broken Mirrors . . . . . . 79

[Her body must've been dumped by the side
    of the road. Must've] . . . . . . . . . 80

In My Mouth . . . . . . . . . . . . 81

Nostalgia . . . . . . . . . . . . . 82

In This Country . . . . . . . . . . . 84

Border Fence . . . . . . . . . . . . 86

Safe House . . . . . . . . . . . . . 87

Hombres . . . . . . . . . . . . . . 88

Source . . . . . . . . . . . . . . 89

Love Poem with Two Fires . . . . . . . . 90

Where Do We Go From Here? . . . . . . . 91

Writing a Poem is Almost Like Climbing a Tree . . . 92

Water Remembers Everything . . . . . . . 93

Alabanza a los que no encuentran su camino . . . 95

Alabanza a las cosas sin lenguaje . . . . . . 96

Las palabras son innecesarias . . . . . . . 97

¿De qué color? . . . . . . . . . . . 98

Estamos hechos de tiempo . . . . . . . . 99

Hervidero en los campos iluminados . . . . . 100

Vuelo de las envidias . . . . . . . . . 101

Is it true that in our deathbeds . . . . . . . 102

¿Volveremos al agua otra vez? . . . . . . . 103

The Sea Forgives Us . . . . . . . . . 104

No recites poemas . . . . . . . . . . 105

Mamá y Papá . . . . . . . . . . . 106

Oración para los desplazados . . . . . . . 107

Acknowledgments . . . . . . . . . . 109

Mamá Y Papá ███████████████

███████████████

██████████████████████

████████████████████████

████████████████████████

████████████████████████

Ya aprendí un poco mas de ingles ████

████████████████████████

████████████████████████

████████████████████████

████████████ Ya no quiero estar aqui

████████████████████████

██████████████████████████

████████████████████

████████████████

██████████████████████████

██████████████████████

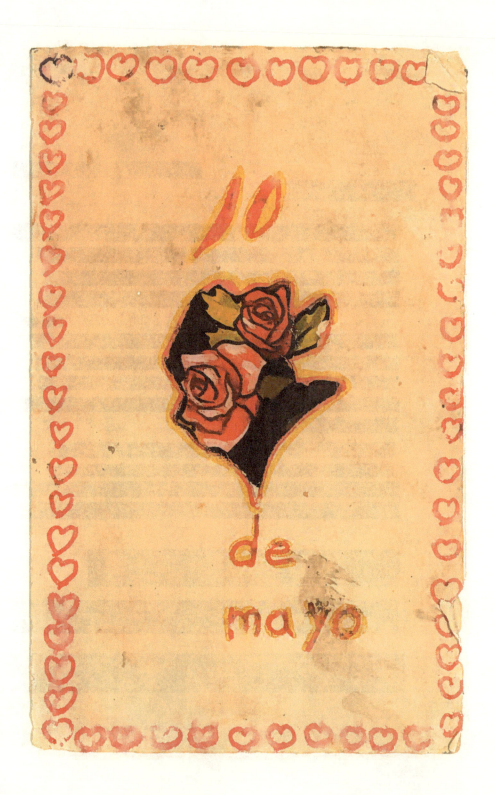

A Mother's Day card is all I have to remind me
that, once, I was a child:

Red hearts on yellowish paper, torn edges.

Mamita
felicidades
en este día
te desea tu hijo

# Vanishing Point

In a hand-written letter
you appear,
offering an answer
like fog. I forget
the question, but it must have looked
like a skinny child abandoned
by God. Yes, God
the one with a capital G,
the one who squints at us
from His great bright Heaven
and nursed the word *abandonment*
into the monster it is.

I am old enough
not to test
your emotions.
I might even be
by now
nothing more
than a casket in my own
children's memory.

What does it matter?
I have made it this far
and still there is nothing
that can heal this rift
between myself
and this boy I have crisscrossed
like uncharted territory.

I have talked to him,
but who knows if he hears what I say
or if he reads what I write.
He is always a boy
when I summon,

and I look down so I can see him,
and he looks up so he can see me,
and there is nothing, nothing
to help us
touch.

# Parting

There was a time
I had no word for *darkness,*
and so, I said, *darkness.*

I had no word to say *devotion,*
and so, I said, *Two sons*
*grieving one mother.*

A time came when our parents
sat under a tree
and sobbed for us, their sons

on their way
to a new country.

When I try to return to my boyhood,

sometimes I end up,     a grown man,
with my head

on my mother's          lap.

# New God

Yesterday, I wanted to buy myself
a new god, one who never tires
of forgiving me,
one who rejoices when I turn
my back on him.
Half-asleep, I imagine I hammer the cross
of the ocean with the nails
of my footsteps.
Yes, I walk on water,
and in the distance
I make out the light
of your station.
Here, we meet underneath the North Star,
and I tell you I want to buy a new god,
one with the courage to break
my fate in two,
one whose hand will guide mine
to your heart so the history
of all your loves can be revealed.
Yesterday, as I invented a new god,
I thought of all the years I claimed
I would surrender
not to be here, contemplated
all the goodness
I have lost.

# Loneliness

As a boy, I would climb trees,
reach into nests birds

would leave unattended.
I would fill my hand

with small eggs, and often
one or two hatchlings

would stare at me
from behind the sprigs.

There were times I wanted
to take them home,

keep them as my own,
raise them, imagined their beaks

one day opening
to call me, "Father."

# Leaving

Quiet the hills.
The does along the edges of their skirts.
Doe heads turning with knowledge.
Their bodies sifting light.
The grass in their eyes giving birth to a boy.
The boy with a dock of black hair.
The boy with a sea for a mouth.
The boy with a storm between his legs.

Quiet the hills.
The clouds brushing against their heads.
Their heads nipping the rain.
The boy becoming a man.
The man becoming a city.
The city becoming a funeral.
And all sound felt in the hips.
Felt in gristle.
Felt in the empty skull.
I am fragile, the man says.
Go easy into my sternum.
Poke easy to touch my blood.
Go ahead. Grow quiet.
Find me by the gate.
Underneath the torn gown
of this night.

# Postscript

\*\*\*

Because you have been separated from your parents, you doodle nonsense
on the margins of notebooks. You move your hand up and down the page
furiously as if something inside of you is unstitching. Or else, your hand is
quiet as if it knows it has nowhere else to go. Between a doodle
that looks like a snarling dog and one like the melting face of an old man, you
scribble, "I miss you," but in Spanish, the language in which you were first loved.

Then you write your mother's name, 'amá.
Nothing more.

You don't know yet that a contraction is a visual form of separation: m      amá.

You think no one will read what you write, and so, you smear the letters with the
   heat
of your fingertips.  A small fire. There. They are gone.

The letters are small and vulnerable. You can do whatever you want with them.

\*\*\*

The American Dream howls outside of your house, calls on your parents,
and through them, calls on you. It promises books. A better life than
what you will live, here, in this country where no one in your immediate family
will be buried.

*El norte*, like the North Star, a promise, across a river, across a fence, across endless
   highways. *El norte*, where you sweep dollars off the street, where you own a washer
and dryer. A TV. Where children do not go hungry. Where children learn to read
and write in English even when their mother tongues shrivel like rotten apples in
   their mouths.

\*\*\*

Make the crossing—not north, but south—south of the Rio Grande. South
of border walls. South of God's left eye.

Find your first language, your parents as you left them, the same dirt patio
where you walked shirtless and barefoot right after a heavy summer rain.
Recover your father's shadow climbing along the side of the house built
by his own two hands; hear your mother's voice following you down
the street on days you believed yourself to be God's loneliest thought.

Here is the life you could have only lived in Spanish. The one you lived
for nine years and that English, this new second language, failed to erase.

\*\*\*

You almost lost everything.
And *almost* has no concrete name. No proper name.
*Almost* doesn't have a country, a playground, an address.

Even if you own a house, you'll never have a home.
Even if you own a dresser, an invisible suitcase will always wait for you
by the door, full of the invisible objects that you will not carry.

The blue hollow of a cup singing the wet morning.
The spoon your mother put to your lips.

\*\*\*

Where are you going?
Where to?
Your uprooting doesn't let you forget that you have no true ground;
the earth opens up its skin for you.
But why, then, do you still feel you don't belong?
You write all over yourself and all over the bodies you touch.
Half of you is invested in the next line; half of you is always waiting for goodbyes.
This is what your being is composed of:

Two lexicons bordered by constants:

English is never enough.
Spanish is never enough.
Language is never enough, and yet, it is the only home you truly know.
Home with broken windows.
Country where you are at least permitted to be a stranger, where you can light
a candle for yourself and not expect to see its light at the edge of sleep.

\*\*\*

*(Mother)* 1

Where is the language that can raise its right hand
and swear to tell the truth?
Where is the language that can shape the first goodbye
of the first time you rode a bus from a small town in Tamaulipas
to a small town in the Rio Grande Valley?
If it is found, how will it tell you about this place,
about detention centers where children were held
because they could not find the American way to open
their mouths and cry for their mothers?
Some so young they could barely form the word.

Hear them trying to say *no te vayas* in English.
Watch them scribble their trauma on the margins of school notebooks.
Watch what they can do with two matches and a corner of dust.

Where is the language that can raise its right hand to loosen
your tongue so that you can tell the world
that you haven't forgotten?

Your whole life has been a quest to find the right words.

But you can only speak for yourself.

\*\*\*

*(Mother)* 2

That first time you stepped on a bus that would drive you
hundreds of miles north, your little brother was with you.
He was eight. And both of you stood on the aisle of that crowded bus,
looking out the half-open window, watching your mother get smaller,
her body not waving goodbye.

If she had, half the sky would have been erased by her hand.

# Manifesto for Wanderers

Where is home / home is in the fire / Where is home / home is in your accent / Where is home / home is in the color of your skin / Where is home / home is in the lightning / Where is home / home is in your mother's dark house / Where is home / home is in your father's abandoned garden / Where is home / home is in the invisible answer / Where is home / no one home

# The Children

The children ask, "When will you come back?"
And there is no answer because no one has an answer.

History keeps rewriting itself in its own image.

In the sky, the clouds pick up their shirts
and show their bones
to amuse the children.

What can be more amusing than this?

# Love of My Life

Tonight, you are not my lover
Tonight, I am not your husband

How hard can it be
to enter my bed as my mother

I am a newborn, feed me
I am the abandoned lamb
The weak hatchling

The branch broken in two
to beat a spoiled child

I am all memory

Be a mother and coo me to sleep
Baby-talk into my heart's ear
Run your hand over my head

You, milk
at the corner of my mouth

# Vulnerability

Some mornings the world is soft.
It sends you a bird you can't name
to chirp outside your window.
The bird could be anyone
you want it to be.
It could be the love you lost
because of selfishness.
Or a younger version of yourself
asking for an apology.
How many times have you dipped
your hand into the mirror
and tried to touch the last ripples
of what you are ceasing to be?
You used to believe in innocence
and now this bird reminds you
that today all you want is
for the bird to keep chirping.
Nothing more.
You have all you want next to you:
a body against your body, your face
half-buried in light,
your arms around all the ripeness
you can possibly hold.

# Four Fears

\*

You're an elephant.
Someone breaks your tusks
and hides them.
You say, *Get out of bed,*
*look for them.*

\*

When I get out of bed
to drink water,
I see my mother's ghost.
*Your mother is not dead,*
you say.

\*

In a dream, I abandon you
before you give birth.
You are afraid to fall asleep.

\*

*Don't be afraid to be lost,* I say.
I now have evidence
of where to find you
waking.

# There will always be a city

that will never belong to you,
a place where all who live there
walk the moonlight on a leash.

Beware: Someone
will always try to wound your stride,
make you kneel,
learn a new prayer.

If you leave the city,
it's because you're no longer in love.
If you sleep, you wake to call
the past by its old name.

There's always a name,
a whimper invisible to sound.

Once you leave, you'll forget
how to return.

You'll find yourself in a small village
where doors are left unlocked,
where dogs chase chickens to their death,
and men invite strangers to sleep
with their wives.

They, too, want to return to the cities
they never wanted to abandon
in the first place.

On days the world
no longer astonishes you,
and all your saints
are prayed for and buried,
what else to do but leave

half your life in a love letter
and let the fire
of your yearning
take the wheel.

# Camaraderie

The ambulances are at it again.
    Someone chokes on a heart attack,
        a child on a bike gets run over,
  a woman walks in on her man
          fucking a stranger.
  It's cold outside, and from your second-floor window,
    you can see white breath,
youngsters leaning against iron-gates.
  They, too, are awakened by screams.
  They, too, have a hole in their dreams.
Now you understand each other:
  While you sleep, someone gets hurt.
Someone steps back from a window's ledge.

# Mexican Pastoral

In the fields, our sad-eyed cows
chew on drops of rain.

I see them, and I see the moon drag
a cord of smoke between two hills.

The rooster crows and the crows point
to the young woman found dead

on the road's shoulder. An onlooker
asks, "¿Cómo andaba vestida?"

Night again. Endless rain will skitter
across our roofs.  The dawn

will arrive an hour late.

## Strong Bond

Sometimes, weeks go by, and I don't call my mother. Sometimes a month goes by and a sign on the side of the road reminds me to call her. Sometimes the surface of my mind forgets she lives, that she still exists in this world.

My siblings probably think of me as heartless, un ingrato, an ingrate. But when my mother came to this country, I was already a man. I didn't need her as much as my younger brothers needed her. They still visit her, call her, make her feel loved.

If my mother were a country, she would be the one I leave behind in search of a better life.

## Essay on Loss

Because I am the horse drowning in the river / because I am the bull not fit for sacrifice / because I miss you / because I lost myself in your humming / because this morning the sunlight was insufficient / because I liked seeing you eat with your hands / because I still remember your mother's voice / because she is now on her deathbed and God has forgotten how to tie her shoes / because I can hear the rooster's dark crow breaking my window at dawn / because I have no door to open and walk back into myself / because my thirst is an unsung song in the universe /

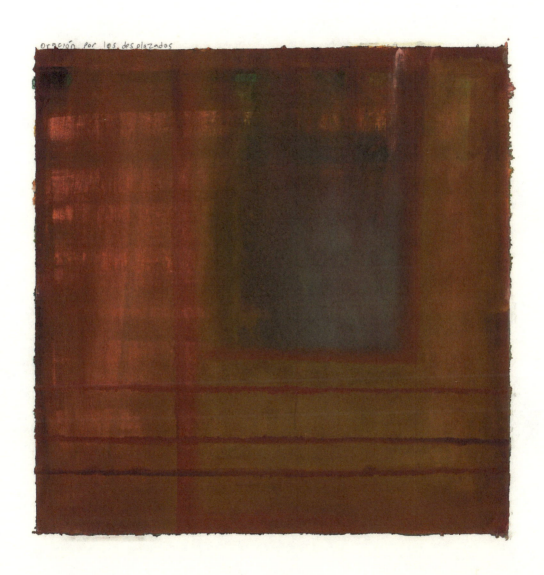

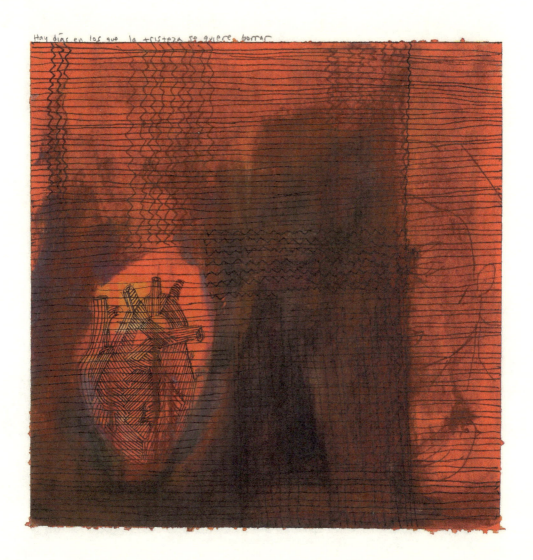

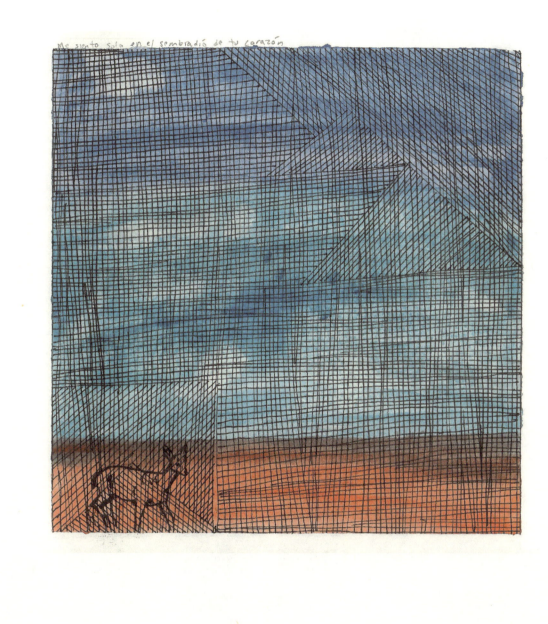

lloro tu nombre

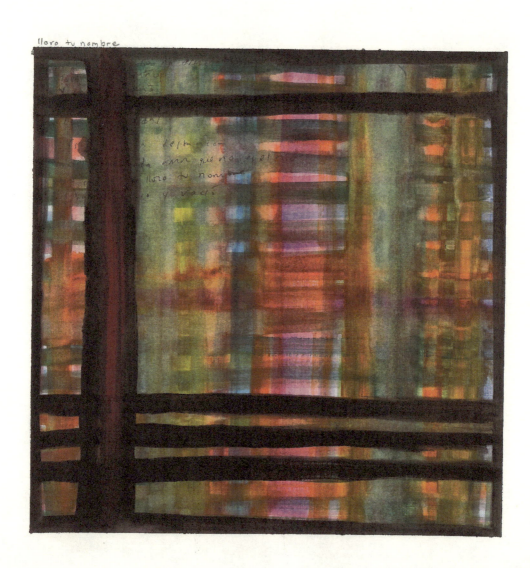

bosque de la las palabras perdidas

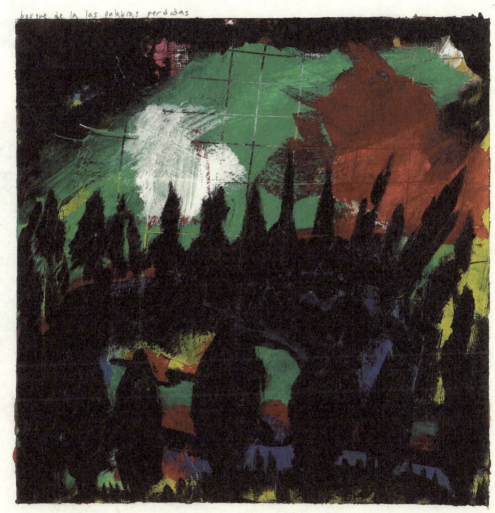

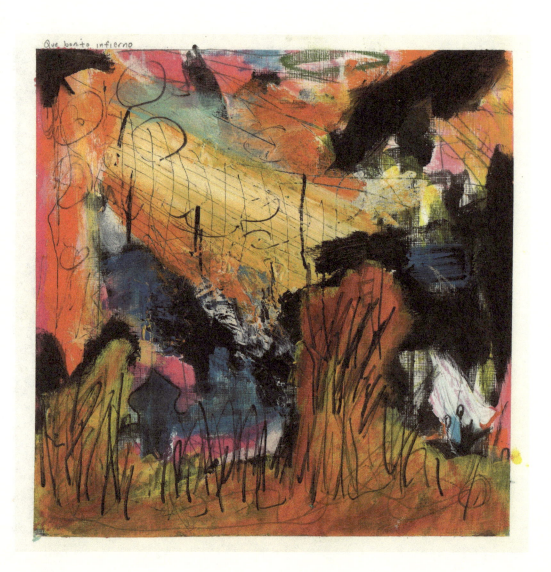

¿Qué parte de tu memoria te duele cuando tienes hambre?

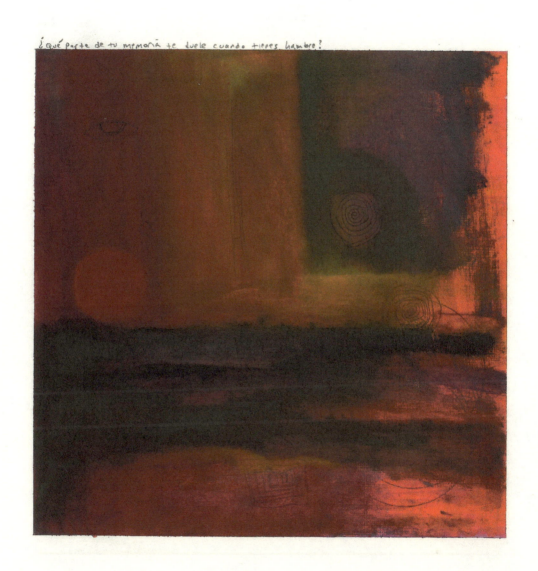

# Self-Portrait with My Father's Eyes

What sum of those who've died still remains with us? What percentage of our memory still belongs to them? When we see our shadow rising against a wall as we walk down a street, does it belong to us? Or is it the way a loved one who has died attempts to say, *I am here.*

Once, I painted a portrait of my father, face made of lines, and within the lines, I could see what I thought had always belonged to me: his eyes, and the way they looked at me, the way *he* looked at me, like a stranger looks at someone he loves.

# Migrations

When my father lost his memory,
he went on remembering he was lost.
I'm in a desert, he said.
Now I'm in a river.

Always in another country
even as he sat on the sofa.
Where am I? he would ask
the news reporter on television.

When he slept, his eyes went on seeing—

The ceiling cut into pieces like cake
by the streetlights. The strange woman
leaning close, watching him sleep.

# Remember

How the day loses a daughter every night
only to not remember her in the morning,

why, I can't say: yet it's as true as two zeros
cancelling each other out in an equation

I've written a thousand times.
I'll keep writing it 'til the fire

of its message doesn't burn
my fingers, 'til my grieving becomes

an open window and I've no more faith
left to jump out of it.

Here, forgive me, for I must travel
through this world without knowing

what it means to sail East, fly North
train West or bus South.

I am losing the meadows
of my native land, and I ask myself,

*What land is my native land?*
My children will never

know how my tongue itches to speak
to the dead, speak to those who took

the accents of the past I memorized
and got them filed in the blurred regions

of their new country. When will they return
to usher me along the forgotten trails?

And if they return, will they say:
*That day, you fell from the skinny branch*

*of a tree and your father lifted you*
*like a wounded sparrow in his arms,*

*carried you to bed? Will they say,*
*You were an obedient boy. You owned*

*a red bicycle, a hand-me down.*
*And you were happy, sometimes.*

*You were sad too when you had no will*
*to invent your own happiness?*

Even now, words don't say enough
about who I think I was before I became.

I wish I could forget everything,
even how I got here, and how I brought you

to this point of my story, knowing full well
that soon you'll remember nothing.

# The Poetics of Separation: A Micro-Essay

Poetry remembers that distance can be made of suffering.

Distance between blood cells.

Between two words on this page.

Between a mother and a son.

And so, I carry my past like a bag full of dirt,
but I can't make words grow out of it
and write what I can't remember:

What is the Spanish word for *water*?
What is the Spanish word for *longing*?
What is the Spanish word for *failure*?

My relationship with language is absence,
one I can't shape with my hands.

Not like clay.
Or fire.

I try.

And for this trying, I rely on what my body thinks it knows.

I allow it to speak to that part of me for which I'll never have words.

This poem doesn't want to tell you a story that you can follow.

It wants to take you to a river, blindfold you,

lower you into its veins.

# Country of Words, a Lipogram

When, without hope, doves
unfold like mist over the open fields,
I know I'm still the fire
trying to burn the word *loss*
on this document.

Some of us will utter songs of grief, clench them
between teeth to remind us how deep,
how worthless, our loveliness.

Isn't our deepest desire to be poetry?
Here, in this moment, on this document,
words rise to christen
this new country formed by this ineludible listening
between you & I,
between bygones & the offing,
between the living & the cold.

Don't worry. When doves unfold like mist
over the open fields, their wings wet with light,
I'll know you're listening to my voice, I'll know
you're burning the wood of your beloved tree,

the one with the sweet flower,
the one you loved so much.

# Why You Never Get in a Fight in Elementary School

In this country,
everything about you is foreign
and no one likes the look of scarcity.
You want to tell them
that when you draw a river
on a piece of paper, a fish
always jumps out of it
and you are always ready to catch it.
You want to be the fish,
but instead, you are a boy
and the home you know
begins to fill with water.
There goes the chair where your father sat
to eat his dinner by the light
of the kerosene lamp.
There goes the only memory you have
of your mother's feet.
You want to tell them that the ocean
where you stand is not an ocean,
but your new country
where your body will be lifted
by all the nameless ways
of missing someone.

# Line & Metaphor (1)

A page limits how far a line travels.

A page never limits how far a line travels.

I've seen lines on the side of the road that look like this — | —

When someone points to the sky, I see the straight line that'd take me straight to
  heaven.

When someone points to the ground, I see the lines on my mother's forehead.

I used to think of Time as a straight line.

Now I sense it can turn into a triangle.

Or it can square itself into a box.

A line of poetry can darken with indiscernible skies.

A line without letters is poetic.

Poetic too are lines without letters making words making poetry.

Some will call it silence.

# Ars Separation

To cross        is to feel

a river           a tree

without       drowning

your parents   in your

                  chest

# Never Been to El Paso, TX

You are black
In the center

Of my eye black
Like the map

Where I draw
My faceless face

Black with the blood
Of my bitten nails

Black like the sharp
Edge of water

That touches your feet
And moves you

To dance black
Like the shore

Where I always
Lose you black

Like the womb
I draw with my awful

Longing black
Between two lines

Of a notebook
Where I have glued

A strand of your hair
Black every time

I open myself
With your name's

Syllables black
When I try to blur

My skin with what's left
Of you black

Is what remains
Black like mist this

Black trail I follow
Black in my days

Cursing the hours
Black like the broken

Windshield of my youth
Black like the highway

I drove thin
To lose you

Black like the ink
Of your tongue

Wake me black in that sea
Wake me black to the taste

# Psalm

Last night I fell asleep
holding my father's hand, Lord,
and I woke with ashes in my mouth.

He tells me he's ready to die,
ready to let the bones of his ghost
perch over the house he built
with his own two hands.

It's the watery gray of his left iris, Lord,
that tells a different story.

He wants to keep hearing
the rooster's crow at dawn
calling him to work.

Wants to hear his wife's slow heartbeat
long before he rises.
Wants to reach the knowing
that You've reached.

Impossible, I know.

I remind him to live
for my mother's sake,
my mother who will die
in a country where her last thought
will be of another.

I say, keep Your ear close
to my brain, Lord.
Listen for the small
motor of grief.

Shut it, if You have to,
so my will, for once,
can bend Yours.

# A Sueldo

When you come to kill me,
be strong like a butcher's forearm.

Don't rush. Study my face
before you squeeze.

Be a boy again and watch
your mother strangle

a chicken to feed you.
Let my blood, pulsing in your hands,

remind you of the shallow river
where you learned to swim

and pretended to drown
a cloud's shadow. Beautiful

days as you watched,
with the corner of your eye,

your sister, unmarried then,
wash clothes by the water's edge.

# Letter to the Afternoon

The dog we tried to hang
knew who I was.
I say *we* because even though I didn't pull
the rope,
I was there.
Something secret in me
wanted the thing done,
and the same secret thing
wanted the rope to break.
No way we could define grace
standing there, shades within
the shades of trees.
Our chests too small to contain
all we felt.
So, it poured out of us,
into the ground, for the wind
to carry like ribbons of silt.
And how do you apologize
to the wind?
The syllables—how far will they travel
and in what branch
will they get stuck?
What animal will mistake them
for leaves and sniff and bite down
into nothing?
All we had left was the clear white jaw
of the afternoon
and a dog's fear too heavy
for an eight-year-old to lift.
So, we let it go,
and it let us go,
and we headed to the shallow river
to cool our feet,
throw rocks at our reflections.

# Letters

It's okay to dip your bread in milk,
        make it soft for your toothless gums
             as you listen for the mailman
              to bring a handful
                 of news from the son
             you haven't seen in more than a year.
        See how the afternoon sits on a bench
            and looks at your sleepless house.
     Hundreds of miles away, the Rio Grande overflows
and doesn't care if you live or die.
        So make tortillas, or give yourself to decay,
   throw yourself onto the knife, longing
       that cuts the minutes
         into tiny eternities.
            The next time you thirst,
                drink his whispers.

# New Country

Your new country a wild dog / your new country a wild church / your new country
bucket of bleach water dumped in the street / your new country *ask for permission,
motherfucker* / your new country blind tongue / your new country drag me to
a tree to hang / your new country burning wick / your new country crooked
vocabulary / your new country no se habla español / Your new country show me
your papers / your new country *I ain't got no fucking papers*

# Final Wishes

Leave it in the open.
Let it feel the sun.
Let the morning light pool
on my navel.

Think before you feel pity.

Think before compassion sways you to bury me.

I don't want to be buried.
I don't want to be a child again.
I'm afraid I'll become a child if you cover me with dirt.

The God I know tells me
I deserve mercy,
yet the pride I am
tells me I don't.

Empty my pockets.
Keep my birth certificate.
Forge your name on mine.
Keep my driver's license
and my mother's photograph.
If you look closely, a year later,
I'll be born.
Take it.
The dead need so little,
after all.

Remember: I'm a U.S. citizen.

What I leave behind must be worth something.

But do me a favor: go to the village I left as a boy
and announce that my body is as dry as sunlight.
Tell them that it's ready to be lifted to the sky
by the smoke
of its own making.

52

# Poem Writing A Suicide Note

By the time you begin
writing this poem,

your father is dead.

This time, it's for real.
Unlike that poem you wrote

in which you have him fall
from a ladder—cracks

his head, loses memory—
but doesn't die.

How much more pretending
must you do?

How small you are
in that mortgage

you'll never finish paying
until you are the age

he was when he died
for real. You keep writing.

In another poem, he is
a construction worker,

South Texas sunlight
hammering his back,

and he dies in the end.
For you, it was all pretend.

53

Most of your adult life
you've been like a five-year old,

faking patricide,
documenting it in poems,

all the while afraid to dirty
your hands with true blood.

Keep pretending to be five
and offer your testicles

for his inspection.
How silly you feel in this memory,

such a tough guy now,
knowing there was nothing

shameful or perverse about it,
just a man making sure his son

had the balls to rise against him,
if necessary.

You'll never finish paying
the student loans you drag

to bed every night.
How much longer will you pretend

the world does everything right
and all you do in the world

is wrong? If you could only believe,
one last time, that missing someone

could be infinite, could outlive you.
Pretend, for your sake,

that maybe it does
that maybe it already has.

# Desaparecer

It's a scientific fact that if you keep your eyes
open for a long period of time,
eventually, all that you see, will disappear.
Like the word *disappear* disappears
in its Spanish translation: *desaparecer*.

Can you hear the traces of what's left,
of what's carried over?

What is left is the chameleon who can move
its eyes in two directions at once,
and not once will you move twice
to save your life.

Desaparecer: meaning *don't get lost, don't die,
come home,*

and your home, empty of metaphors,
and your metaphors, empty of mercy,

and you find yourself either writing
about a quiet country
that you no longer remember,

or about a name that still hurts you
when you dare whisper it in the dark rooms
of your empty kingdom.

Maybe we should be friends: I'll be
your accomplice, the *I* pronouncing itself,
the eye that stays open so you can see
the truth in the opposite of *disappear*.

Don't worry about this now,
for even if you lose your sense of sight,

you'll still be able to see your dreams.
You'll be able to see what they who burn
without light can't.

How do you quantify the fractions
of your life that have nothing to do
with seeing?

Tell me and I will tell you
that sometimes I wake trembling
at not finding you next to me,
and I fall asleep feeling the opposite
of holy, untranslated

on the blank of your face,
and I see nothing left
to carry me over.

# Drawing the Line

In Mexico, when men met in a field, I would often see one of them,
often my father, pick up a stick and draw lines on the ground.

What did he draw? Who knows? I was six or seven years old. Memory's line
   doesn't reach that far. Only the line sketched by a tiny plane in the deep blue sky.

# Elegy for Your Absence

Tonight, I am calling my mother back
                  to her bones, calling her back
                          so that she can sit on the threshold and stitch
                                    the hours with her day-dreaming.

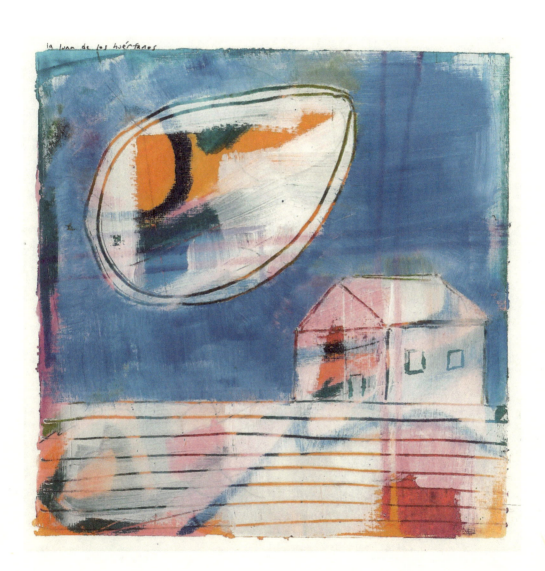

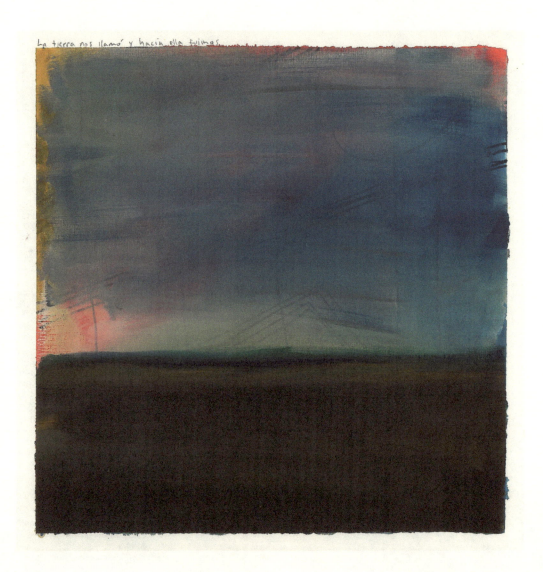

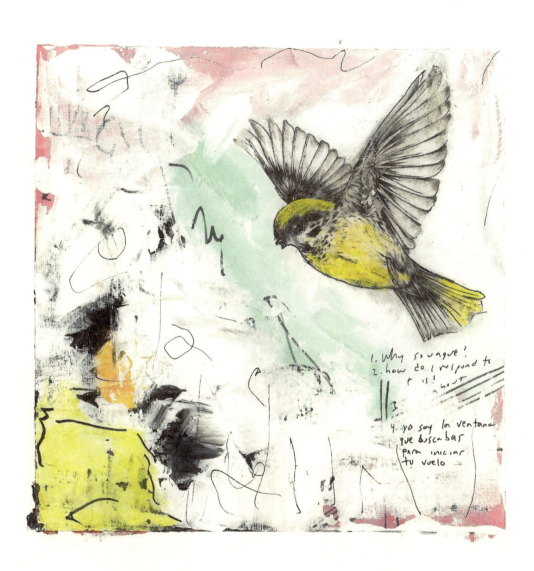

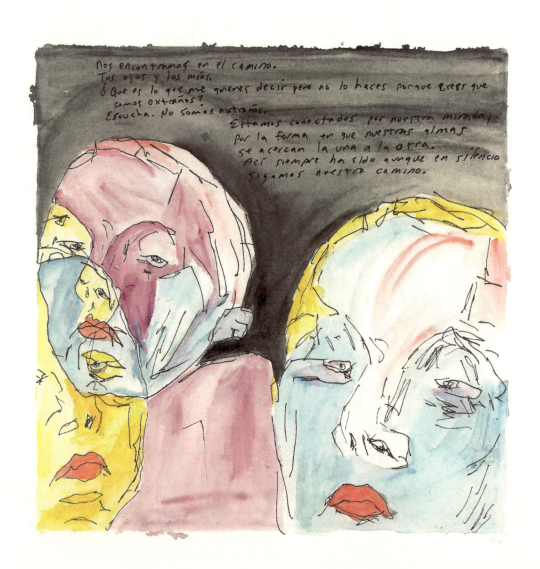

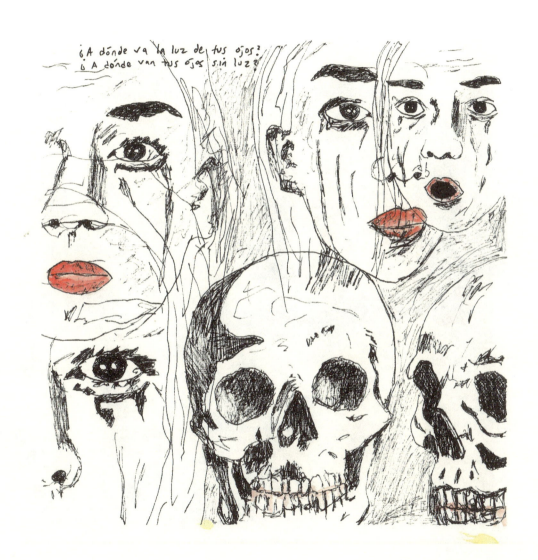

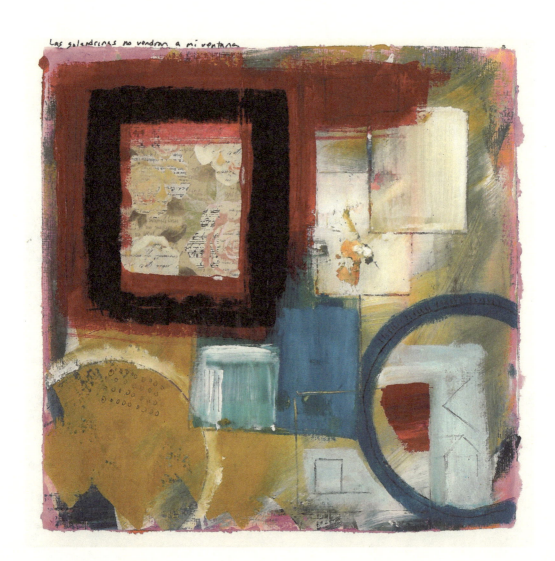

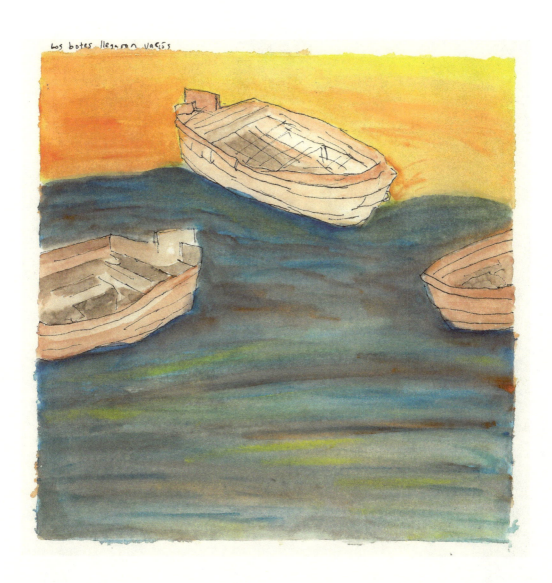

# Line & Metaphor (2)

How a line begins doesn't have to be understood by the senses.

A line is the breath of someone crossing a river.

To follow a line means that you're often unsure of how to trace it back to the beginning.

Your future is composed of straight lines, or jagged lines, zigzags, barbed wire.

Sometimes two lines living in two different countries never intersect.

Sometimes they do.

If they do, they do not cease to be lines trailing the trajectory of their own lives.

I'm not sure about this last claim, but for now, I'm following this particular line of thought.

Writing requires me to follow a line that differs from drawing or painting.

I'm trying to hold the line that keeps all of me in one piece.

I'm trying to erase the line that keeps all of me in one piece.

If this were a poem, I'd encourage you to add a line to it.

Who's to say this line is not a poem?

Sometimes when I begin to draw a line, the shadow it begins to cast is human.

Sometimes when I begin to draw a human, I run out of lines.

I've always liked drawing or watching someone draw the # to play tic-tac-toe.

Once, instead of drawing two vertical lines crossed by two horizontal lines,
   I drew this:

I lost that game.

When I begin to draw a line, I know it'll be a journey to a question I'll never answer.

I think the above metaphor evokes a line as possibility.

To begin a line doesn't always mean you'll find your way back home.

# Despierta

My father's black cow
            ambles
into my sleep.
             I poke it
             close
             to its asshole
             like when I was seven,
                   urging it to drink
                   water
                   from a hair-thin
                   stream.
What I wanted then
must have been
truer
than what I think
I want
now:
                   I want to see my father
                   walking towards me.

                   But how can I make anything new
                   out of old things
when I still wake
with a tongue of salt.

Rain is still rain,
distance is still distance,

and there is nothing I want more
than to be the sadness
in the cow's eyes
when it turns to gaze at me.

# My Despair as the Voice of God

Not necessary to be transformed
Into a bull
Nor dress in an angel's fur
Each commandment
A vise for you
But for me ten ways of boasting
My power
Still you're the dark voice
Grieving in the desert
The body's bellow
The bellow's dagger
Profane water gushing
Between my three brains
Among all things
Blessed is your love

# Elemental Waiting

I prayed to the empty parks,
I prayed to the sunlit roads,
I prayed to the childish God
of my childhood
to make a knife
out of my blessings.
I prayed the corpses
I carried in my heart
could be lifted and drowned
in the black fields
where lonely bulls grazed.

Listen, I'm writing what I can't remember
as if this sowing is all that matters, and it isn't.

No one is here to touch me, no one is here
to fill my center with sand.
What word to pack a wound?
What wound to fill a mouth?
The parks never answered my prayer.

God just clapped his hands
and sent rain to drip from the trees.

# [You take a picture of your father]

You take a picture of your father
with your new cell phone,

the last one you'll take of him,
thin and frail, looking like a praying

mantis as he brings his hand
to his mouth with a piece of bread.

If he pretends to eat, it's to appease
your hunger to see him eat

and not to appease what no longer
gnaws his belly, no longer the hollow

he knows. It's over, and you know it,
hours all you have now after wasting

years in silence, and you walking the same path
as his to reach this moment

where you hold up your heads
like dim lamps and face each other,

all light now as you search in his eyes
for anything that doesn't require

words, a doorknob perhaps
that opens the sky before you.

# Fig of Unfolding

Tonight, I expect the only star in the sky to be
so bright I'll forget all I know about sorrow,
how it feels like sandpaper against skin,
how it looks like the old woman my mother has become.
I was still a boy when I watched my father plant a fig tree
in the back yard, me not knowing much about the fruit it promised,
but enough knowing about the river running through
my father's quiet as he dug a hole to make his offering.
Ever since, I've been running in the opposite direction
of hope, trying to logic my way out of God's existence.
It gets tiring tunneling through time till I get close
enough to see an exit and then time begins again, but this time
without the people I have loved. A day will come
when my body will no longer open like a suitcase
to take myself on a journey where I'll dream
of never being found, where I'll dream of never finding
what I've lost. I no longer have a need for it, no more fig tree,
no more father, the backyard sold long ago to strangers.

# Gregor Samsa's Sister

I, too, forget her name, your sister's,
when I'm in bed and think of her,

my wife, next to me,
reminding me,

as she sometimes does,
that she never knew her father.

What was her name?

Hard to remember anything
after I see her ride a train somewhere

my life had always
wanted to go.

It's how your story ends,
and hers begins,

a train, and she standing up,
at one point, from her seat,

stretching her young body.

I imagine, by this time, it's no longer
weighed down by duty,

her body, a symbol,
I'd argue, of what's left

after grief bleeds out.

I'm almost sure I misread
the whole thing.

Or maybe I don't remember
as much as I think I do,

but every time I think of your sister
extending her youth

like a map
for all to behold,

I wish I could give the woman
who sleeps next to me

directions to a past
where she can have the chance

to meet the man
she grieves for.

And then to lie in bed for hours
till the rain taps the window

with its knuckles, wondering
if there's someone

in the world I've fathered
who's unaware of my existence.

To discard disquiet like an earring
on a stranger's window sill.

To let it be a gift to someone else.
But the world rewards so pitifully.

You and I are made
of the same unhappy dreams,

the same quiet that closes
and opens all frontiers.

Deep at night,
when I think of her,

your sister,
I want to ask my wife to hold me,

*hold me*, I want to say,
*until all my flesh burns off*

*and all that's left is light.*

# Broken Names Like Broken Mirrors

Like a window, the first letter of my name
opens inside the mouth of a lover I had
      to give up
because she said I didn't have the answers
she wanted.
How to make her understand that there are no true answers, and too many
poems written about the names
given to us by those who claim
to love us:
my name on a passport, my name on a job application, my name
      tattooed on the softest part
of her wrist.
Some nights I'd think she could be anyone's lover
and I'd still forgive her, save anyone
who, in some way, looked like me: my hair, my eyes,
the color of my skin.
Not that, please.
Everything else, yes,
even this loneliness that she could never touch;
and touching someone else now, I feel
I am still touching her with it, which is to say,
she's nothing but an obscure reference
in a poem now, dark
like the sound of rain
on a metal roof.

# [Her body must've been dumped by the side of the road. Must've]

Her body must've been dumped by the side of the road. Must've
tumbled down the edges of the wild till it stopped at the foot of a tree.
There, her mind must've given up its last shudder, her body must've
understood that this was it. There would be no going home.
There would be no more breath against a cold window to draw a heart
with an arrow through it. She must've forgotten her own name.
All her thoughts by now strung together by a thin prayer her mouth
would not utter. No sound to save her. No sound to let her know that hope
should be the last thing to die. She must've thought of her mother. She must've
thought of her father, the man who whispered the first poem into her ear,
no sonnet, but two words that made her feel safe. *Te quiero*.
She must've thought of the previous day when she walked across a field
to meet the boy who kissed her for the first time. Afterwards, her mouth sticky
with honey and wonder. Afterwards, all her insides folding in.

# In My Mouth

In my mouth the mouth of my daughter,
In her mouth the mouth of my son,
In his mouth my mother's prayer,
In the mouth of the prayer,
The lost harvest my father tried to bring back
With his breath.

In my mouth the mouth of my youth,
In its mouth the mouth of empty money.

In my mouth something other than my mouth:
My daughter's hair becoming one with the dark,
My son's voice calling my name.

# Nostalgia

\*

The wind arrives on all fours,
and I imagine that the foal we named "Huerfano"
is loose in the cornfields once again.

The foal with sad eyes, eyes swollen with honey.

\*

I follow the plow's pull, slitting
the earth in two.

A voice with two sparrows
for a throat
calls me.

I think it's my father's.

\*

I am the ox reflected in the water.

I am the hill in the distance
where a wooden cross

rises against the sky.

\*

I carry the shadow of the slain horse.
The shadow of the air soaring through your black hair.

Look at the shadow of this altar
where my mother's portrait
also casts a shadow.

\*

Tonight, nostalgia is a lit candle in my chest.

# In This Country

We turn off the light,
      & after two minutes

          in the dark
our hands seek

each other
      under the covers, feeling

something is
      afraid & the clock

can't help, & neither
      can any hope we promise

in our trying.
      At this hour, what we love

most begins
      to question itself

& wants some sort of
      confirmation

      that everything
still makes sense,

that is,
      it's becoming more

difficult to believe we're
      eternal even when

your hand presses
its pale alphabet

on mine,
even if it answers

yes

# Border Fence

Heavy your hunger.
Like a small country you carry on your back.
A country like El Salvador or Guatemala, places you've never been to.
When you arrive to it, you feel the steel in your hand.

Cold as if touching your wife's spine for the last time.

See, it's not as big as you imagined.
You thought that to scale it your feet would have to climb even after your death.
But it's so small.
Like the narrow waist of a river when the rains don't come.
Like a country that never keeps its promises.
Squint your eyes and see a jackrabbit in the distance jumping it with ease.
See how you can pick it up with your fingers and move it out of your way.
So small.
Like your hand between its open ribs.

# Safe House

My neighbors burned last night
in a house fire.

I never saw them.

I would see, however, two, sometimes three people
enter and exit the house, always
near dark,

their faces tending to blur, half-covered
with caps and hats.

They never looked my way, never waved
their hands to say hello, goodbye.

This morning, I wanted to call you, let you know.
But I didn't.

Firemen came and strangled the blaze.
Policemen stood at the edge of ashes
to scribble and photograph.

Then they were gone.

I wondered who would claim the dead,
who would sweep the ashes of their names?

# Hombres

The fields vibrating with buckshot, evening
     like a horsetail trailing the light's dim promise.
My uncle brings home the half-open mouth
     of a white-tailed deer, the rest of its body
follows, antlers heavy
         like a wooden cross.
         I am small, press myself against my father's legs,
the massive animal on the table
         built sturdy for times like these.
         Under the lightbulb gently swaying in the humid air,
the men drink beer
         and point to the only star willing to testify
on their behalf.
         I am curious about death, but I've never seen
the meadows where the grown men go,
         never alone to rub wilderness
           all over my arms and chest.
Staring into the buck's dead eyes,
     I know I will be alone one day,
     in a field all atremble with evening,
the dying light's bristle against my face,
     the torsos of the men who loved me
     laced with the earth's skin.

# Source

*Come... watch this.*

I slip my hand
into its half-open mouth,

                enter another life.

          After our kill,
I teach my boy
to unfold

the rifle
into the sheet
of paper it is.

          He'll see
               the soft jaw
                    it becomes.

          For now, the stag
               bares its tongue
                    like a bleeding rag.

# Love Poem with Two Fires

First, I dream my teeth are falling off and I try to push them back in place.

Then, I dream I take things out of my mouth.
Cotton, for instance, or a woman's endless braid of hair.

I see my future move ahead without me
and no one comes to explain what I am
ceasing to be.

My best nights
are when I dream
you are a fire in the middle
of the wilderness.

I am your favorite tree burning
in that fire.

# Where Do We Go From Here?

Once, I felt I didn't fit into my own name. Felt too big for me, like an oversized shirt. When you cross a river from the south to call the land in the north your new Motherland, your name follows you like an injured dog, and also your history. My father is buried in South Texas, close to the river he crossed undocumented countless times to work, to live, to love. He's the first of kin to permanently find a home in this country. With a first-grade education from Mexico, this man built an empire of possibilities. Now the children of his children speak Spanish all mocho, Tex-Mex, Frontera-speak, and they have no accents, and they graduate college, and they find their future here and not elsewhere, like those who came before them did. Our dead are here now. Their descendants keep growing like trees. Does this mean that we have finally earned the right to truly say, "We belong here"? In this country? In this land? In this moment?

# Writing a Poem is Almost Like Climbing a Tree

I am writing and I am thinking about what I write.

I am trying not to plagiarize myself.

My mother said, "What will you do when I'm gone."

I said, "Where are you going?"

She didn't answer, but I thought about how I would write this down,

how I would mythologize her sentence and mine.

I am writing and I can't help but feel I am rewriting the myth of me.

With what letter does your grief begin?

Have you named it?

Like a pet.

Like the trees baptized by the wind.

Having been born a day after I was meant to be born, my name will never be a seed.

Because of this, no one will remember what a tree looked like.

For now, wave goodbye from atop your crown

to a past that waves you back into its arms.

# Water Remembers Everything

In a dream,
    the water doesn't speak,
        doesn't tell you anything,
doesn't tell you how much you've aged,
    how much weight you've gained,
        how the house
      where you were born
    has been lost,
  how strangers live there
and have no idea who you are.

When you wake,
    your mother's mind remains
        a silver lake
      where you dip your name to see
    if you can raise it
  whole again.  And you do,

because
    *El agua lo recuerda todo,*
      and it remembers you
        as you stand here once again
      in the shadow of your thirst,
    seeing yourself smile
  in the glass.

Alabanza a los que no encuentran su camino

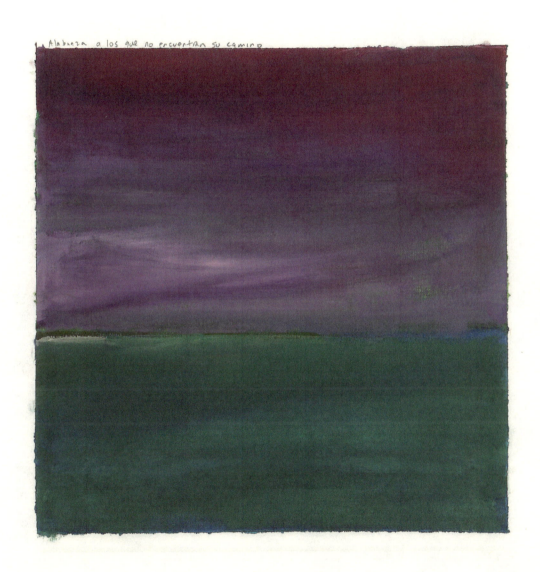

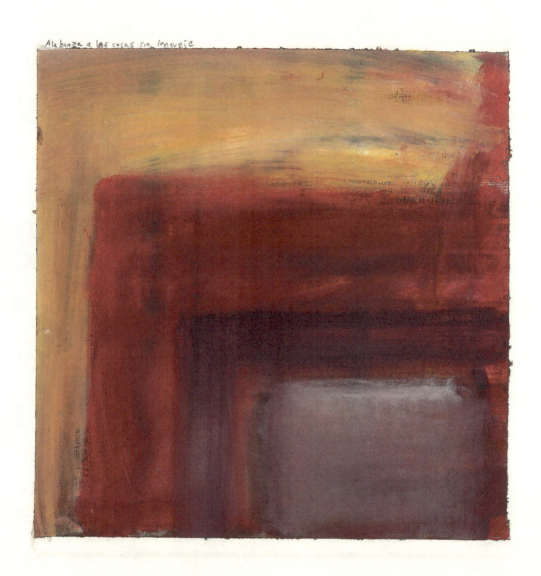

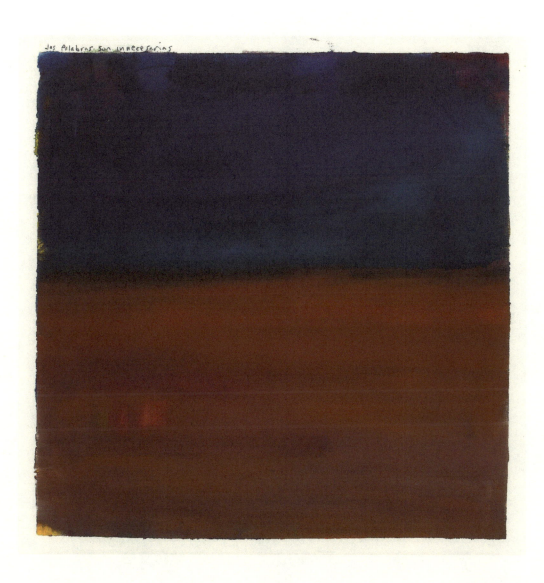

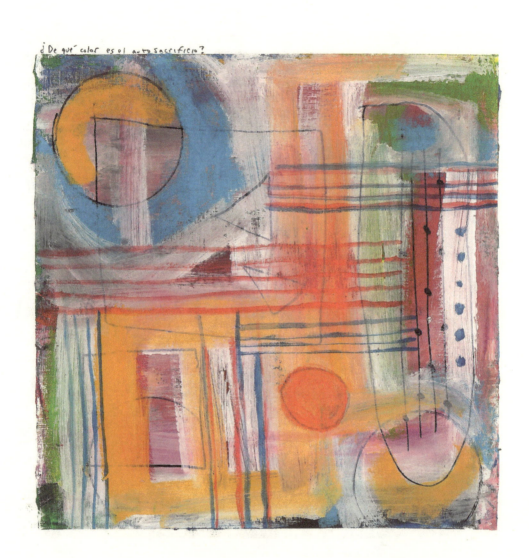
¿De qué color es el autosacrificio?

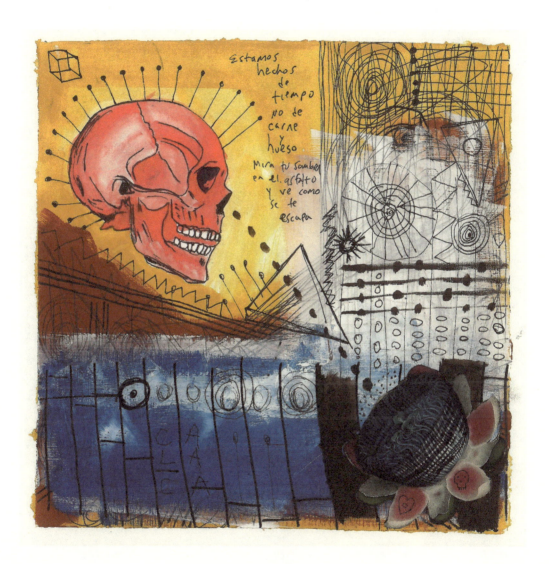

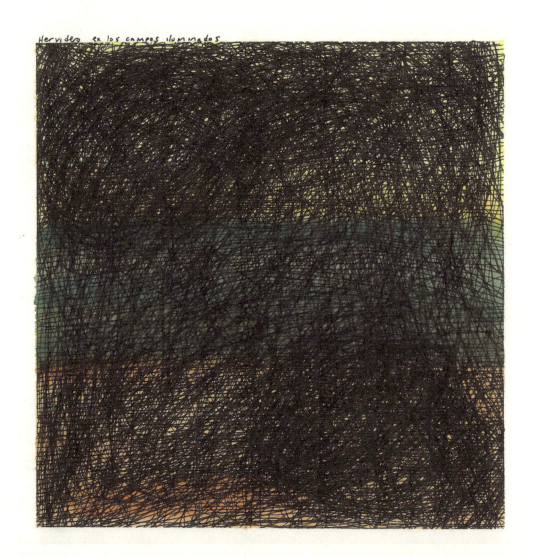

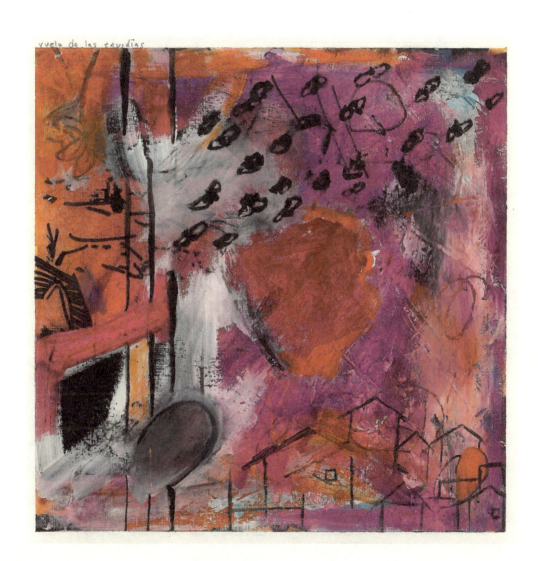
vuelo de las envidias

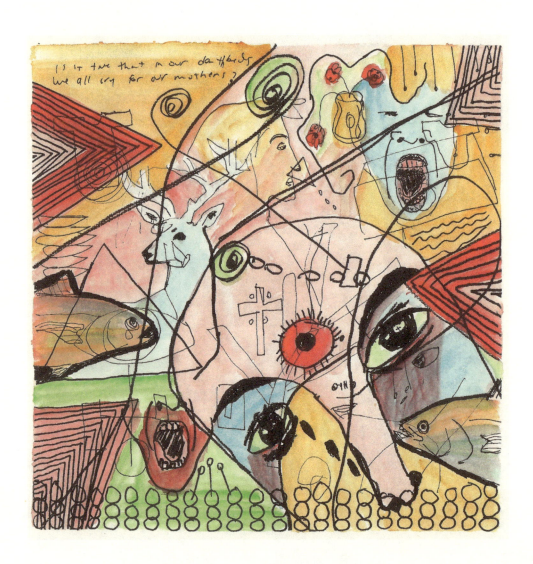

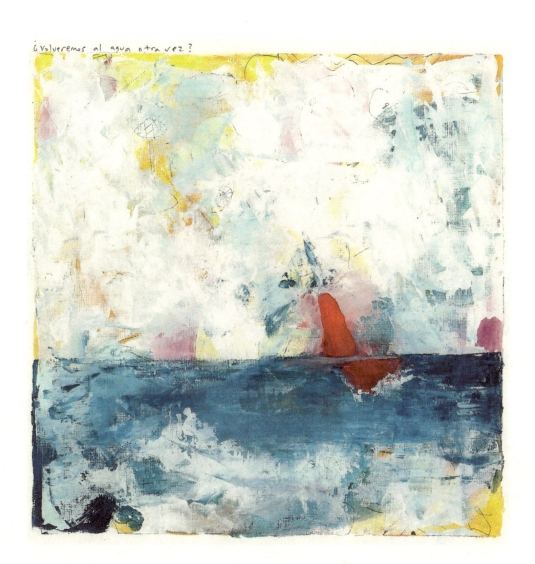

¿volveremos al agua otra vez?

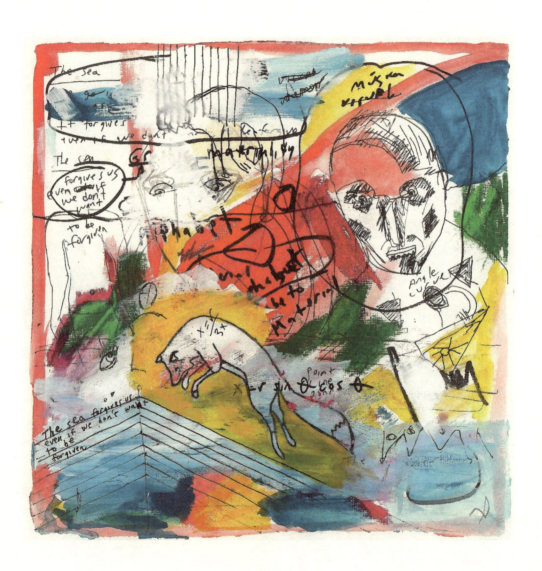

Mamá y Papá: ▮▮▮▮▮▮▮▮

▮▮▮▮▮▮

▮▮▮▮▮▮▮▮▮▮

▮▮▮▮▮▮▮ no nos emos en

Fermado ▮▮▮▮▮▮

▮▮▮▮▮▮▮▮▮▮

▮▮▮▮▮▮▮▮▮▮

▮▮▮▮▮▮▮▮▮▮

▮▮▮▮▮▮▮

▮▮▮▮▮▮▮

▮▮▮▮▮▮ began muy Pronto.

▮▮▮▮▮▮▮

▮▮▮▮▮▮▮

▮▮▮▮▮▮▮

# Oración por los desplazados

*(A translation of the hand-written Frontextos)*

\*

Prayer for the displaced.

There are days when sadness feels permanent.
Days when I feel alone in your heart's harvest.
I cry your name: wilderness for lost words,
beautiful hell.
What part of your memory hurts
when you are hungry?

\*

Orphaned moon: The land called us
and we wandered towards it,
not knowing that you are
the window we open to leap out of
to begin again.

\*

We find each other: your eyes,
my eyes. What is it that you want to say,
but don't say because you think
we are strangers?
We are not strangers.
We are connected by our gaze,
by how our thoughts reach for one another.
It has always been like this,
even if the journey we take
towards each other
is made of silence.

\*

Where is the light of your eyes?
Where do they find their darkness?
If the sparrows don't come to my window,
our lives will remain empty.

\*

Praise to those who never find their path.
Praise to the things without language:
Words, not necessary.
What is the color of your self-sacrifice?

We are made of time, not flesh and blood:
Look at your dark portrait on the asphalt
and see how it wants to escape you:
Swarm of dark energy in the illuminated fields,
flight of envy.

\*

Is it true that on our deathbeds
we all cry for our mothers?

\*

Will we return to water again?
The sea forgives us
even if we don't want to be
forgiven.

\*

Do not recite poems
at the hour of my death,

                        amen.

**108**

# Acknowledgments

The poem, "The Water Remembers Everything" is part of San Antonio's "Poet's Pointe," a pocket park located at the intersection of West Magnolia Avenue and West Mistletoe Avenue (2509 W Mistletoe Avenue) in Council District 7.

Thank you to the editors of the following journals in which many of the poems in this book appeared, often in earlier forms:

*Arcadia:* "Parting," "Loneliness," "Camaraderie," "Gregor Samsa's Sister," "Her Body Must've Been Dumped by The Side of the Road," "Letters," & "Mexican Pastoral"

*Atunis Poetry:* "New God"

*Borderlands: Texas Poetry Review:* "Line & Metaphor" "A Sueldo," & "You take a picture of your father"

*Connotations Press:* "Love Poem with Two Fires" & "Never Been to El Paso, TX"

*Existere: Journal of Arts and Literature:* "Migrations"

*High Noon:* "My Despair as the Voice of God"

*Huizache:* "Psalm"

*Levure Littéraire:* "There will always be a city"

*Nepantla Familias: An Anthology of Mexican-American Literature on Families Between Worlds:* "Why You Never Get in a Fight in Elementary School"

*Poetrybay:* "Essay on Loss" & "Love of My Life"

*Poetry Northwest:* "Postscript"

*San Antonio Express-News:* "Letter to the Afternoon"

*Southampton Review:* "Country of Words, a Lipogram," "Remember," & "The Poetics of [Separation]: A Micro-Essay"

*Texas, Being: A State of Poems* (Trinity University Press, 2024): "Hombres."

*Walt's Corner:* "Vulnerability"

*Zócalo Public Square:* "In This Country"

# About the Author

OCTAVIO QUINTANILLA is the author of the poetry collection, *If I Go Missing* (Slough Press, 2014) and of *The Book of Wounded Sparrows* (Texas Review Press, 2024). He served as the 2018-2020 Poet Laureate of San Antonio, TX. His poetry, fiction, translations, and photography have appeared, or are forthcoming, in journals such as *The Southampton Review, Salamander, RHINO, Alaska Quarterly Review, Pilgrimage, Green Mountains Review, Southwestern American Literature, The Texas Observer, Existere: A Journal of Art & Literature*, and elsewhere. His Frontextos (visual poems) have been published in *Poetry Northwest*, Texas Review Press, *Borderlands: Texas Poetry Review, Midway Journal, The Langdon Review of the Arts in Texas*, and elsewhere. His poetry and Frontextos can be found at the San Antonio Labor Plaza, and at Poet's Point, a San Antonio community space.

Octavio's visual work has been exhibited in numerous spaces, including the Mexican Cultural Institute in San Antonio, TX, El Paso Museum of Art, Southwest School of Art, Presa House Gallery, Brownsville Museum of Fine Art, and Emma S. Barrientos Mexican American Cultural Center / Black Box Theater in Austin, TX.

Octavio is the Founder and Director of the Literature and Arts Festival, VersoFrontera, and the Founder and Publisher of Alabrava Press. Octavio holds a Ph.D. from the University of North Texas and is the regional editor for *Texas Books in Review*. He is the recipient of the Nebrija Creadores Scholarship which allowed him a month-long residency at the Instituto Franklin at Alcalá University in Alcalá de Henares, Spain. He teaches Literature and Creative Writing in the M.A./M.F.A. program at Our Lady of the Lake University in San Antonio, Texas.